WAL

HISTORY TOUR

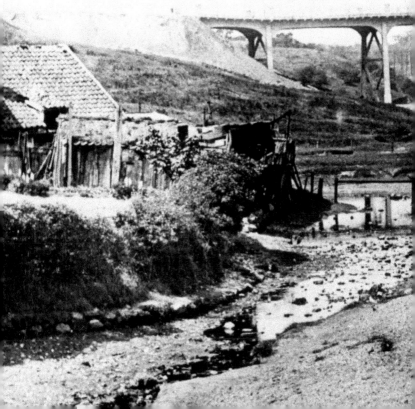

Map contains Ordnance Survey data © Crown copyright and database right [2015]

First published 2015

Amberley Publishing
The Hill, Stroud,
Gloucestershire, GL5 4EP
www.amberley-books.com

Copyright © Ken Hutchinson, 2015

The right of Ken Hutchinson to be
identified as the Author of this work
has been asserted in accordance with
the Copyrights, Designs and Patents
Act 1988.

ISBN 978 1 4456 4862 0 (print)
ISBN 978 1 4456 4863 7 (ebook)

British Library Cataloguing in
Publication Data.
A catalogue record for this book is
available from the British Library.

Typesetting by Amberley Publishing.
Printed in Great Britain.

INTRODUCTION

Wallsend has constantly changed over time and continues to do so. It started life as the Roman fort of Segedunum in AD 126 and soon developed a *vicus*, or town, outside the fort walls to accommodate the soldiers' families, local businesses and the bathhouse. Over the next three centuries the fort and the town saw many changes.

When the Roman occupation ended in the fifth century, the fort was eventually abandoned. The stones were used by the monks of Jarrow and Tynemouth as well as local farmers, and the land reverted back to agriculture. A new township developed at Wallsend Green away from the riverside, probably to avoid Danish or Viking raiders using the river. In the mid-twelfth century, Holy Cross church was built midway between the villages of Wallsend and Willington to serve the communities of farmers in the townships. From around the same time a small settlement grew up on the riverside around the local salt pans at Howdon Panns, later developing other industries including shipbuilding, rope making and whaling.

From the late 1700s, coalmining commenced in the area; colliery houses were built close to the many pit shafts and waggonways were built to transport the coal to the River Tyne, where it could be loaded onto ships. 'Wallsend Coal' was world famous for its quality and in 1835 the worst ever mining disaster took place at Wallsend Colliery, with the loss of 102 men and boys.

By the early part of the twentieth century, shipbuilding and coalmining dominated the town as terraced streets were developed to house the expanding workforce.

Major employers were to dominate the town from this period up until the 1980s including Swan Hunters, North East Marine, Wallsend Slipway, Clelands, Cooksons, Haggies Ropeworks, Thermal Syndicate and Rising Sun Colliery. Wallsend High Street also developed as the main shopping and entertainment area with pubs, music halls and later cinemas meeting local needs.

Following the First World War, the style of housing changed in Wallsend from terraced housing to suburban estates to house the rapidly expanding population of the town. Following the building of the Coast Road in the 1960s, major housing estates were developed to the north including Battle Hill and Hadrian Park.

ACKNOWLEDGEMENTS

This book has been written on behalf of Wallsend Local History Society and all proceeds from the royalties will be shared between the Society and St Oswald's Hospice in Newcastle. The society was established in 1973 and meets in St Luke's church hall, Frank Street, at 7 p.m. every second Monday of the month.

I wish to record my special thanks to all who have helped me in the past and especially to those recently active on the committee. I have used a number of photographs from the society's collection as well as some from the private collections of Beatrice Clark, Marjory Hall and Doris Thurlbeck.

I would also like to thank North Tyneside Libraries for the use of a number of old photographs from their excellent local studies collection. Special thanks are due to Diane Leggett and Martyn Hurst. I would like to take this opportunity to encourage anyone who has any old photographs of buildings or scenes in Wallsend to make them available to the Local Studies Library in North Shields Central Library or to Wallsend Local History Society.

My thanks are also due to the staff at Segedunum Roman Fort, Baths and Museum and the Committee of Friends of Segedunum. Finally, I would like to thank my wife, Pauline, sons, Peter and David, and granddaughter, Isla, for their encouragement.

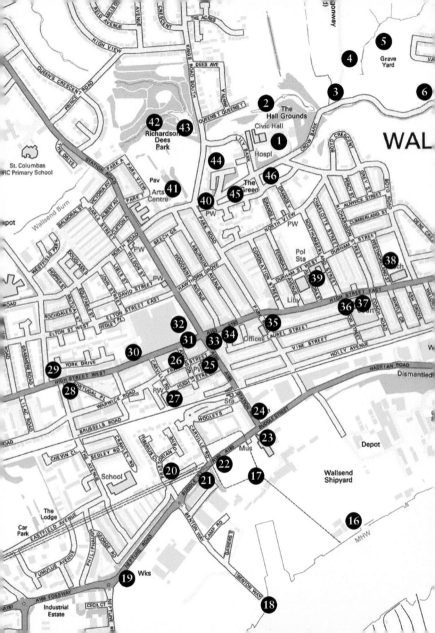

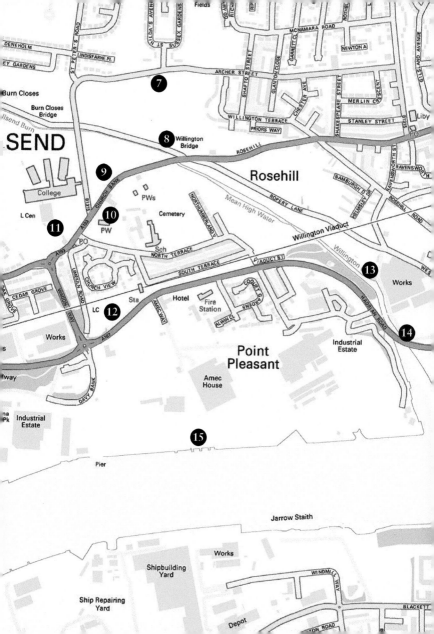

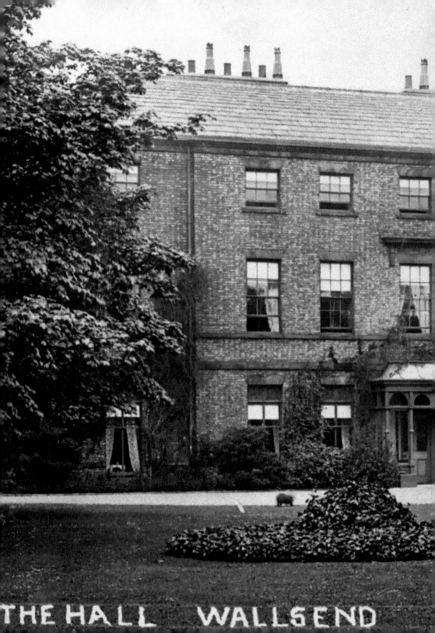

THE HALL WALLSEND

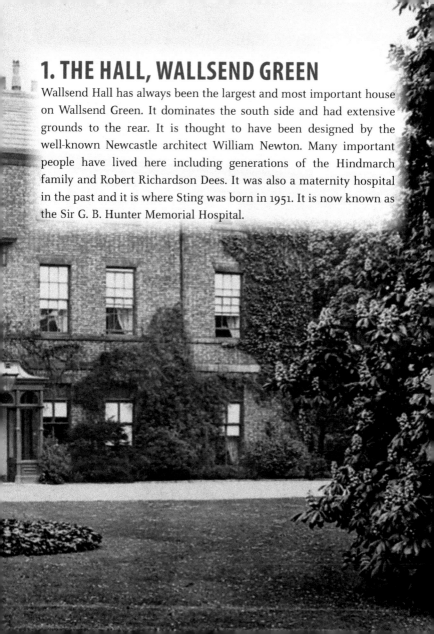

1. THE HALL, WALLSEND GREEN

Wallsend Hall has always been the largest and most important house on Wallsend Green. It dominates the south side and had extensive grounds to the rear. It is thought to have been designed by the well-known Newcastle architect William Newton. Many important people have lived here including generations of the Hindmarch family and Robert Richardson Dees. It was also a maternity hospital in the past and it is where Sting was born in 1951. It is now known as the Sir G. B. Hunter Memorial Hospital.

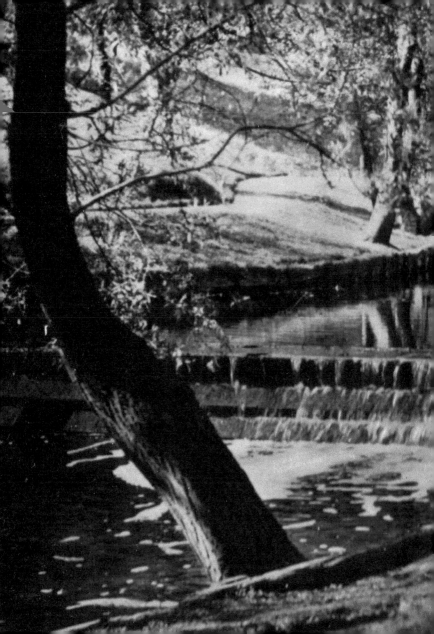

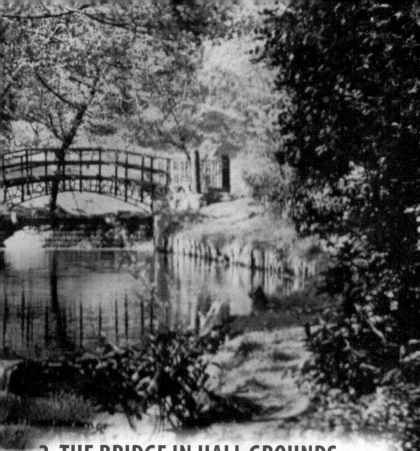

2. THE BRIDGE IN HALL GROUNDS

The hall grounds are now a public park but were once laid out as pleasure grounds connected to the largest house on Wallsend Green, Wallsend Hall. The ornamental bridge, seen in the early 1900s, was one of many features in the pleasure grounds, which also included a grotto and vinery. Sir George Hunter gave both the hall and its grounds to Wallsend Corporation in 1916.

3. KILLINGWORTH WAGGONWAY BRIDGE

In the background of the inset image, a farmer is seen leading his cows past the Killingworth Waggonway bridge with the old Wallsend pumps in the foreground. The bridge served Killingworth Colliery, transporting coal to the River Tyne and it was demolished after 1940. The Wallsend pumps provided water for residents of Wallsend village centred on Wallsend Green; they were removed some time after 1914. The site of the bridge is now obscured by trees, as seen from the view taken from Holy Cross steps.

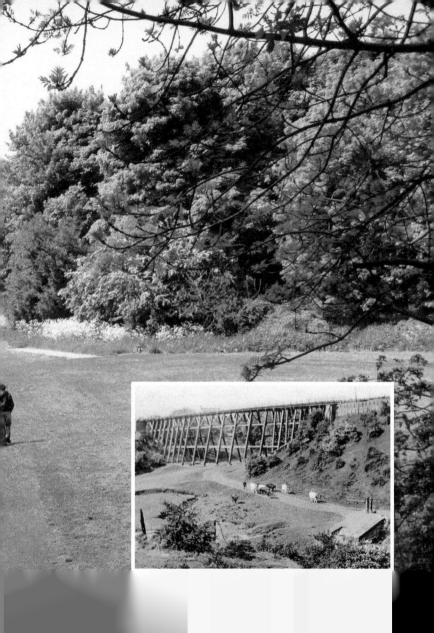

4. WALLSEND DENE

In this scene, looking north towards Wallsend Dene, cows are being led towards Crow Bank on the way to one of the farms on Wallsend Village Green. On the hill to the right, behind the tree, are the ruins of Holy Cross church. Only the base of the Wallsend pumps has survived.

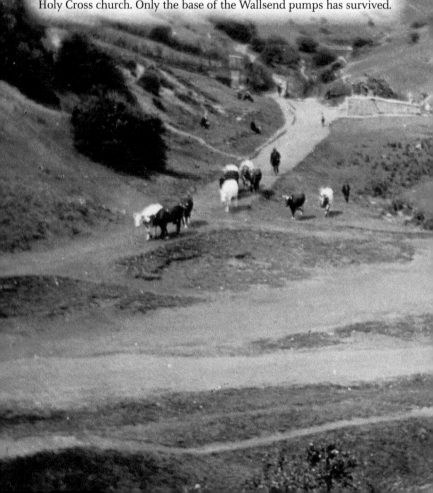

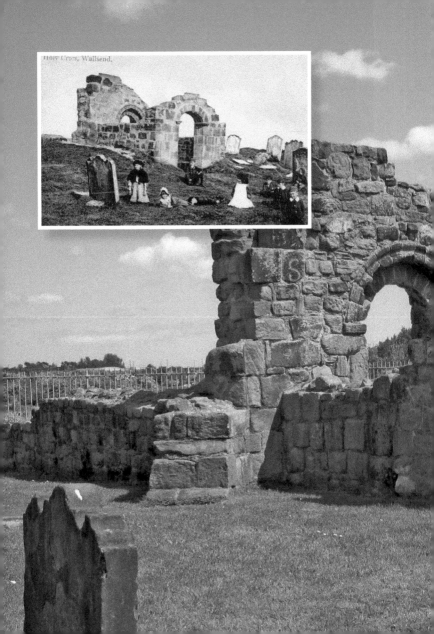

Holy Cross, Wallsend.

5. HOLY CROSS CHURCH

Holy Cross church was built around 1150 to serve the villages of Wallsend and Willington and continued in use until 1797. The original Holy Cross church was neglected and fell into a ruinous state. Following a campaign, the church ruins were consolidated in 1909 and the present metal boundary fence was built around the area. The gravestones were removed and placed within the reduced churchyard.

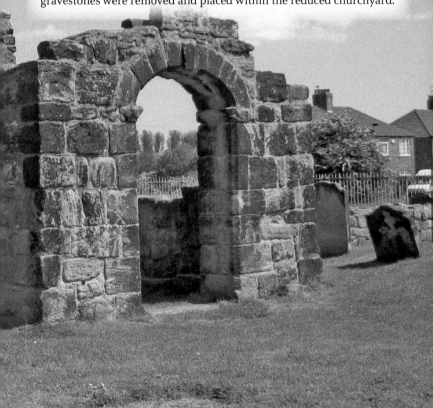

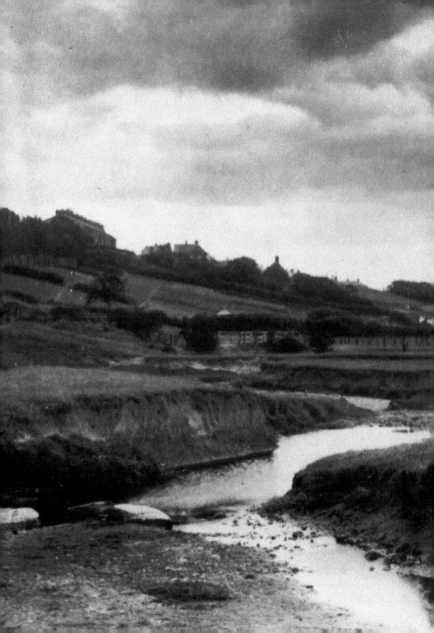

6. WALLSEND BURN AND VIADUCT

Wallsend Burn is seen meandering through the Burn Closes with the Willington Viaduct in the background. The picture must have been taken before 1913 because the new Rose Inn has not yet been built and it was also before improvement works took place to realign the course of Wallsend Burn.

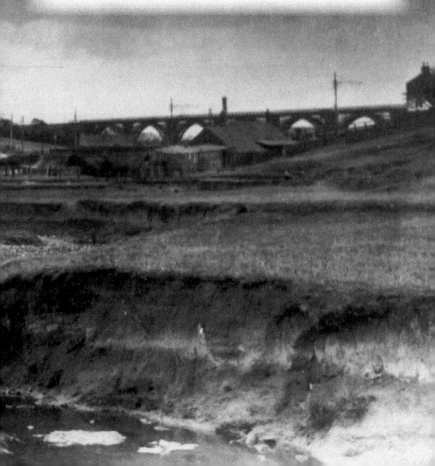

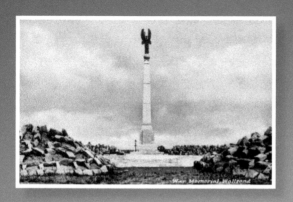

War Memorial, Wallsend

7. WAR MEMORIAL, WALLSEND

The obelisk is a rare design for a war memorial in the North East. This memorial in Archer Street was erected following the First World War in the early 1920s. It is made from granite and supports a bronze winged figure of Peace standing on a polished granite sphere .

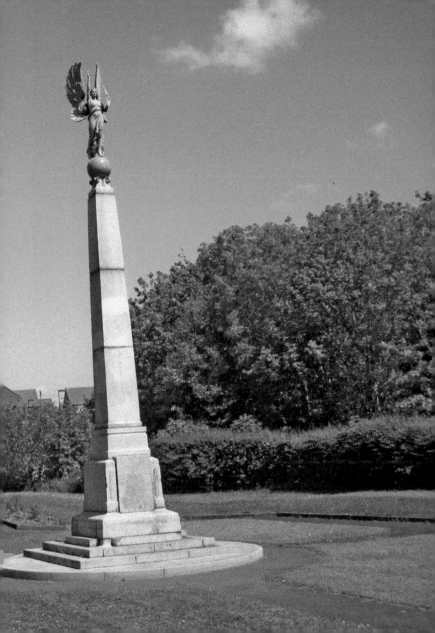

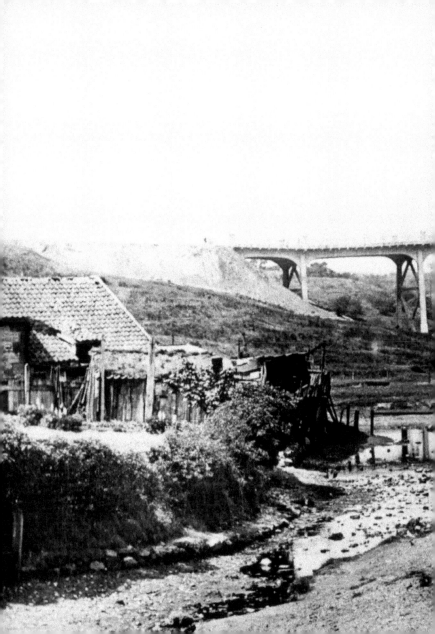

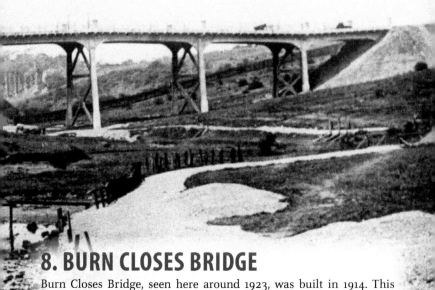

8. BURN CLOSES BRIDGE

Burn Closes Bridge, seen here around 1923, was built in 1914. This uniquely designed ferroconcrete bridge was built by G. Wier Builders and later became a listed building. Unfortunately, over time, the bridge developed major structural problems and was demolished in late 2008.

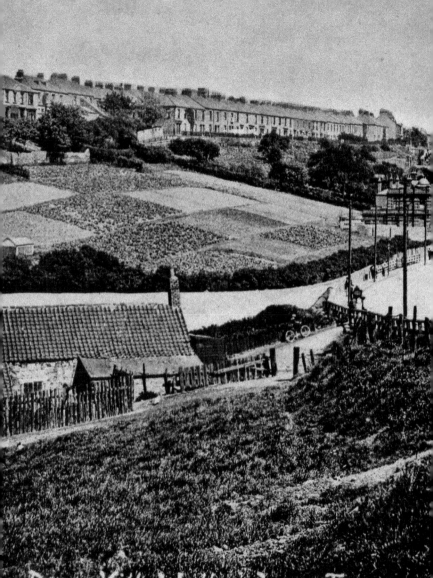

Rose Hill, Wallsend-on-Tyne

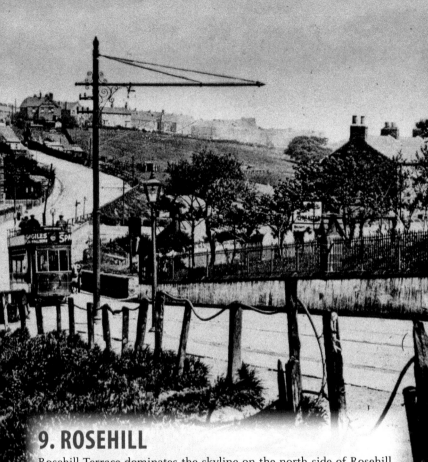

9. ROSEHILL

Rosehill Terrace dominates the skyline on the north side of Rosehill Bank. Just beyond the tram travelling down Church Bank the new Rose Inn can be seen. The picture must be dated after 1914, as that was when the pub was built.

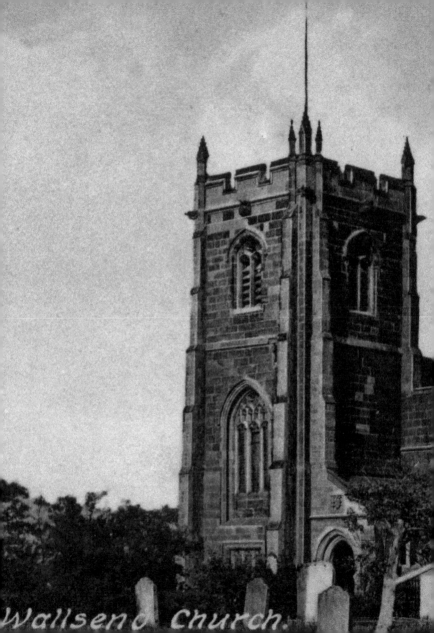

Wallsend Church.

10. WALLSEND CHURCH

Wallsend or St Peter's church is seen in the 1920s and was built in 1809 to replace Holy Cross church. Sabbath breaking in Wallsend must have been a problem in the nineteenth century as stocks were installed in the church grounds in 1816 to punish those who missed the Sunday services.

11. GRAMMAR SCHOOL

In 2003, the impressive architecture of the former Wallsend Grammar School had changed little from the original building built as Wallsend Secondary School and Technical Institute in 1914. It became Wallsend Grammar School in 1944 and Burnside High School in 1969. The present Burnside Business & Enterprise College was built behind the site of the former grammar school.

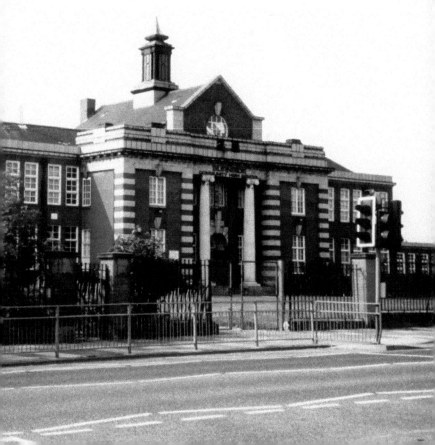

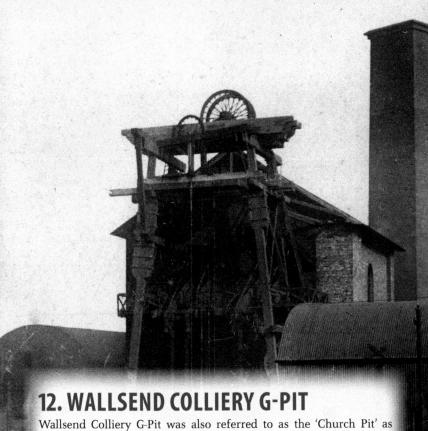

12. WALLSEND COLLIERY G-PIT

Wallsend Colliery G-Pit was also referred to as the 'Church Pit' as it was close to St Peter's church. The original railway line to North Shields was opened in 1839 (now the present Metro railway line) and separated the two. Hadrian Metro station lies immediately east of the G-Pit first sunk in 1802 as part of the famous Wallsend Colliery and it was later used as part of the Rising Sun Colliery until 1934. The Rising Sun Colliery itself closed in 1969 when coal mining ceased in Wallsend after nearly 200 years.

13. WILLINGTON MILL

Willington Mill was erected around 1750 on a bend in Willington Gut and was originally known as Proctor's Mill, after the original owner who built a large house beside it. The photograph was taken in 1893 and shows the seven-storey mill in the foreground with Proctor's house behind it. All that remains of the mill complex is Willington Mill, which has been reduced to four storeys and now has a curved roof. Willington Mill is famous for its ghost, sometimes referred to as 'Kitty'.

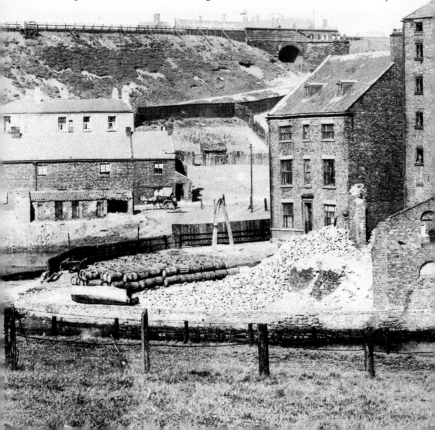

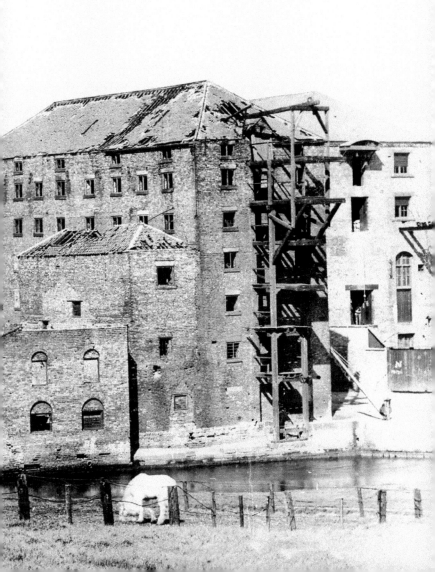

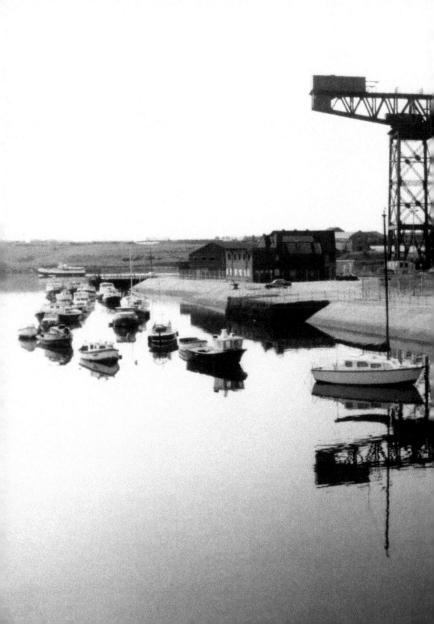

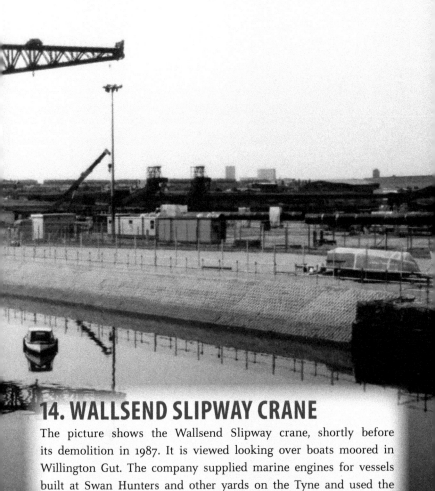

14. WALLSEND SLIPWAY CRANE

The picture shows the Wallsend Slipway crane, shortly before its demolition in 1987. It is viewed looking over boats moored in Willington Gut. The company supplied marine engines for vessels built at Swan Hunters and other yards on the Tyne and used the massive hammerhead crane to lift the engines into the ships.

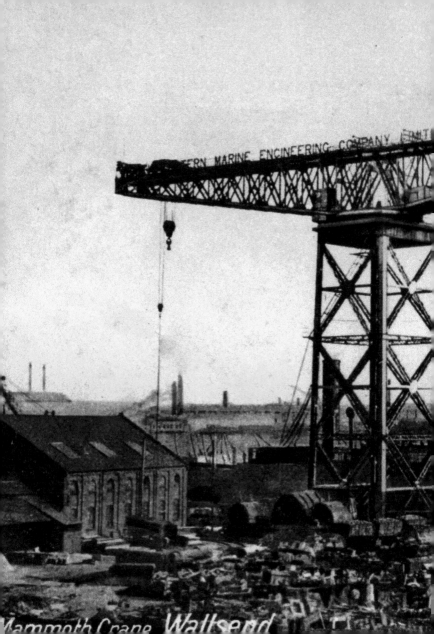

Mammoth Crane. Wallsend

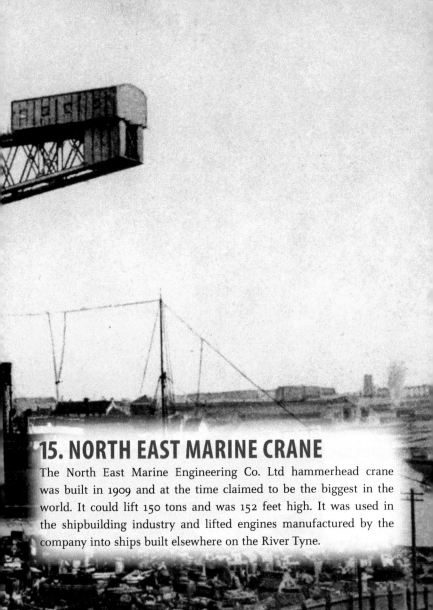

15. NORTH EAST MARINE CRANE

The North East Marine Engineering Co. Ltd hammerhead crane was built in 1909 and at the time claimed to be the biggest in the world. It could lift 150 tons and was 152 feet high. It was used in the shipbuilding industry and lifted engines manufactured by the company into ships built elsewhere on the River Tyne.

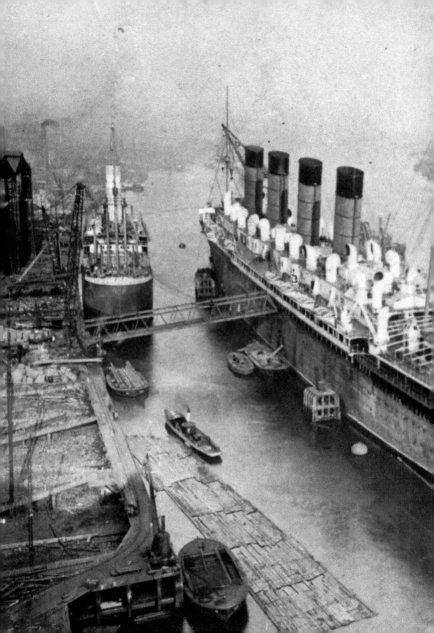

16. *MAURETANIA*

The *Mauretania* was the most famous ship to be built on the River Tyne. It was completed in 1907 and was the biggest and fastest liner in the world. It held the record or 'Blue Ribbon' as the fastest ship between Britain and America for over twenty-two years. The shipyards of Swan Hunter and Wigham Richardson were amalgamated in 1903 to bid for and complete the contract for the Cunard Co. The ship was powered by locally designed Parsons' steam turbine engines that were manufactured at Wallsend Slipway.

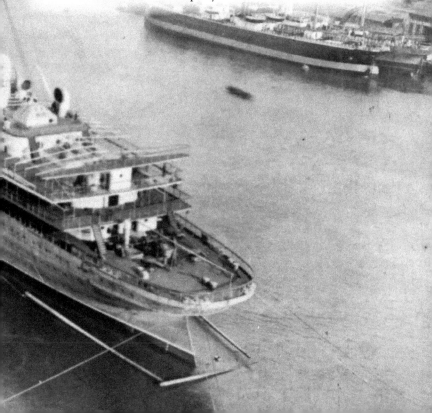

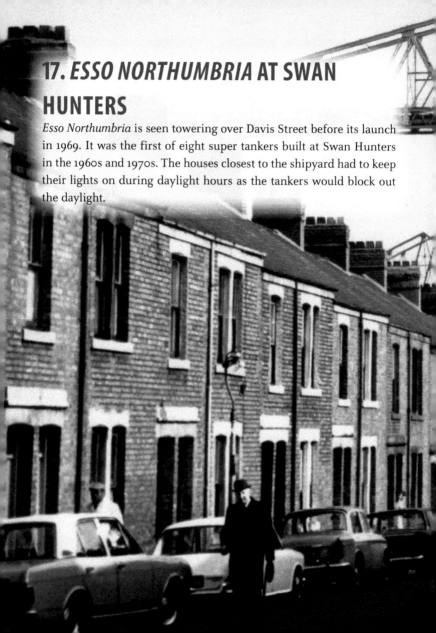

17. *ESSO NORTHUMBRIA* AT SWAN HUNTERS

Esso Northumbria is seen towering over Davis Street before its launch in 1969. It was the first of eight super tankers built at Swan Hunters in the 1960s and 1970s. The houses closest to the shipyard had to keep their lights on during daylight hours as the tankers would block out the daylight.

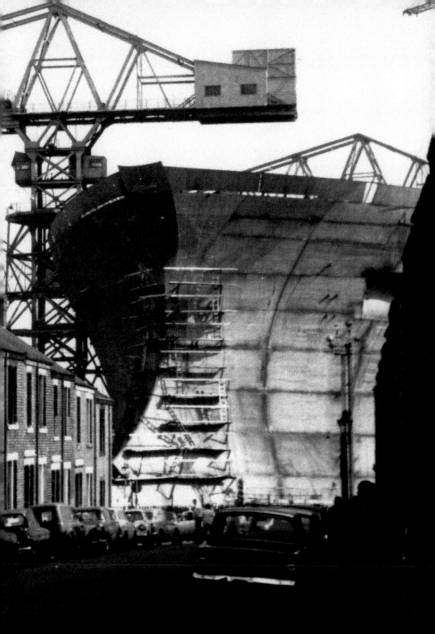

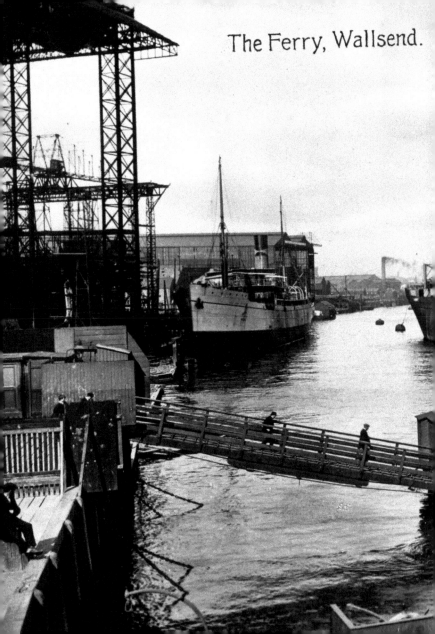

The Ferry, Wallsend.

18. THE FERRY LANDING

Wallsend Ferry Landing was situated at the end of Benton Way. The Hebburn to Wallsend ferry opened in 1904 and closed in 1986 as shipbuilding had declined on the river. The photograph is taken looking over the ferry landing at Swan Hunters shipyard.

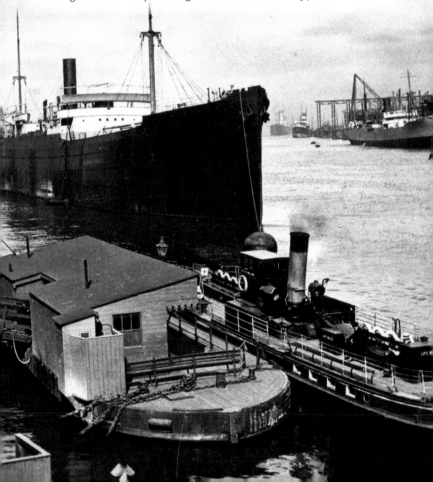

19. NEPTUNE ROAD

The photograph was taken around 1915 looking east along Neptune Road and shows buildings on both sides of the road, with the main offices of the Gas Board, later Thermal Syndicate and after that the Carer's Centre, immediately on the right. On the left, shops and housing front on to the main road linking Walker to Wallsend. The main tram works were located behind the Thermal Syndicate offices. All the roadside buildings on the north side of the road were cleared away in the 1970s and replaced by landscaping.

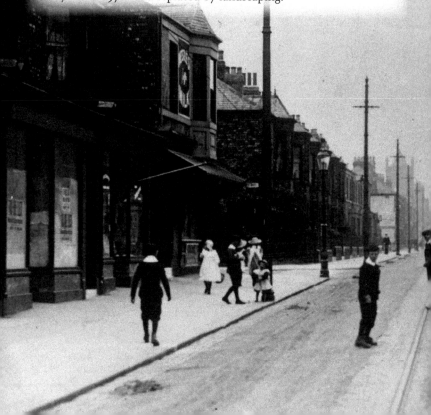

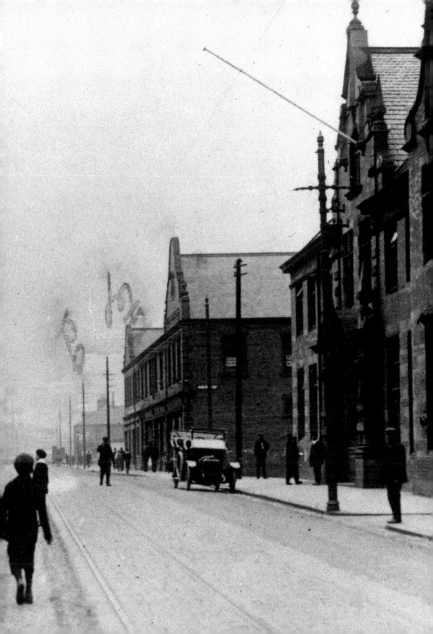

20. WALLSEND CARVILLE CHAPEL (OLD COLLIERY CHAPEL)

Wallsend Carville Wesleyan Methodist chapel or Old Colliery chapel was built in 1812 to serve the miners working at the nearby Wallsend Colliery. It was the building used to hold the inquest into the worst ever mining disaster to take place in Britain up to that time. On 18 June 1835, 102 men and boys lost their lives within a few feet of the chapel following an underground explosion. They were buried in a mass grave in the churchyard at St Peter's church.

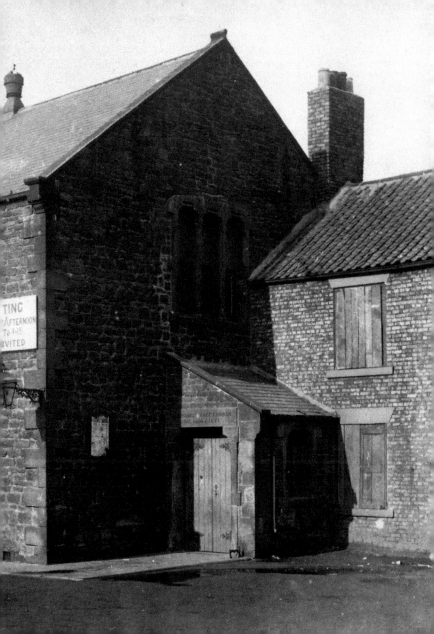

21. WALLSEND COLLIERY A-PIT

Wallsend Colliery A-Pit is seen here in 1838. It was situated immediately to the west of the west ramparts of the Roman fort of Segedunum. In the background is the house of John Buddle, the famous Wallsend Colliery viewer or manager, who was regarded as a local expert in all matters concerning mining. Wallsend Colliery was famous for producing the highest quality coal from the high main seam, which was 6 feet 6 inches thick and 666 feet below the surface. All other local collieries would list their coal as 'Wallsend' to get the highest prices in London. Charles Dickens even referred to Wallsend coal in one of his books.

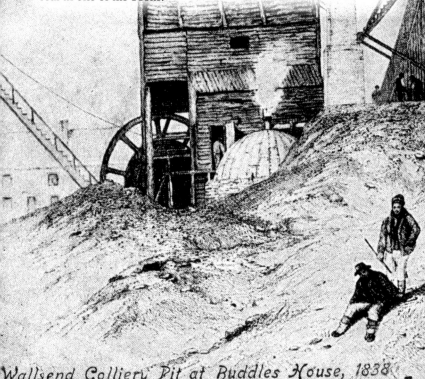

Wallsend Colliery Pit at Buddles House, 1838

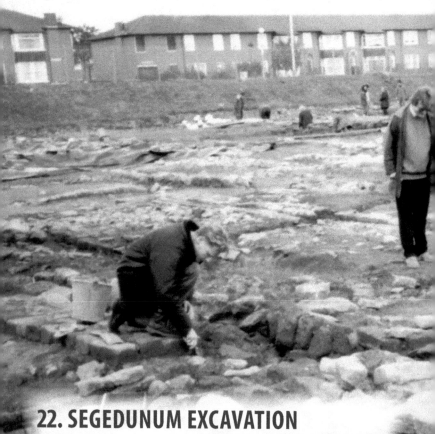

22. SEGEDUNUM EXCAVATION

Wallsend fort is the most excavated fort on Hadrian's Wall. In 1998,
Dr Nick Hodgson is standing on the site of the hospital building
explaining to visitors how the Romans may have used the only
double-seated toilet to be found on Hadrian's Wall. In the background,
workers are busy excavating. The picture (inset) was taken on 17 June
2000 at the opening of the new Segedunum Museum and shows Bill
Griffiths, the curator of the museum.

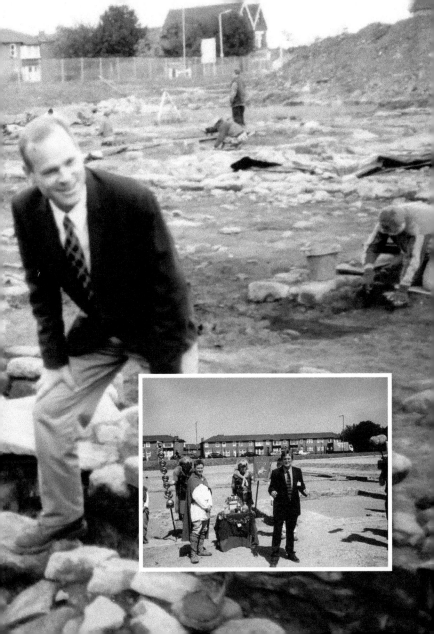

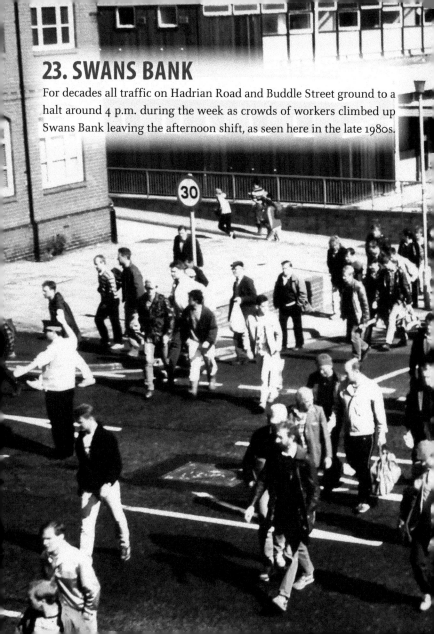

23. SWANS BANK

For decades all traffic on Hadrian Road and Buddle Street ground to a halt around 4 p.m. during the week as crowds of workers climbed up Swans Bank leaving the afternoon shift, as seen here in the late 1980s.

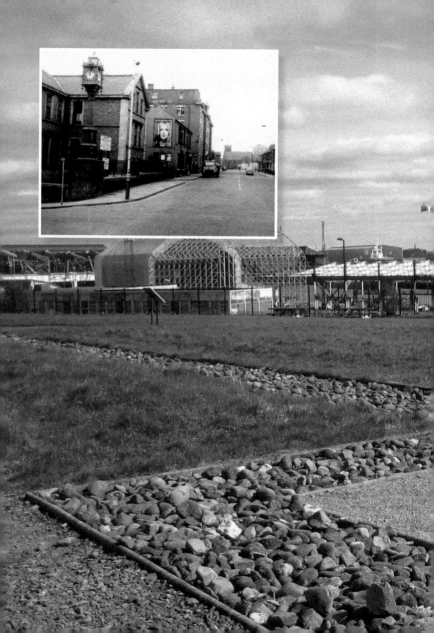

24. BUDDLE STREET

The inset photograph shows Buddle Street in the 1960s before demolition works started, exposing the Roman fort of Segedunum (*main picture*). The Swan Hunters Institute Building is seen behind the clock at the top of Swans Bank in the inset and the large building behind it is Simpsons Hotel – a local landmark until it was demolished in the late 1980s. Rows of houses led off Buddle Street to the north and south to house local workers.

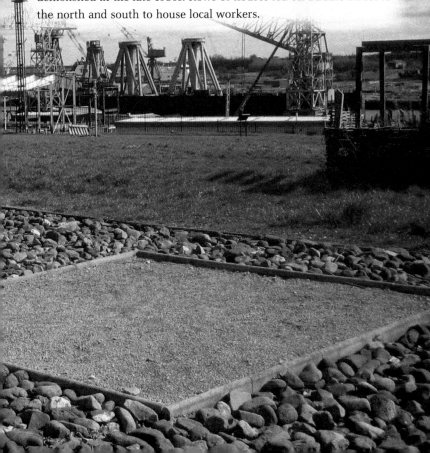

25. ST LUKE'S CHURCH

The postcard of St Luke's church dates from around 1909 before the shops were built on the corner of Frank Street and Station Road and the Memorial Hall on Frank Street. St Luke's church was built in 1887 and the vicarage in 1903 in response to the massive expansion of shipbuilding in Wallsend. Large areas of new housing were developed close to the riverside and St Peter's church could not cope with the extra demand from the increased population, so a new parish of St Luke's was created.

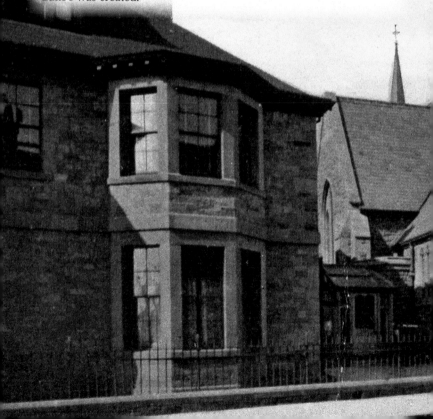

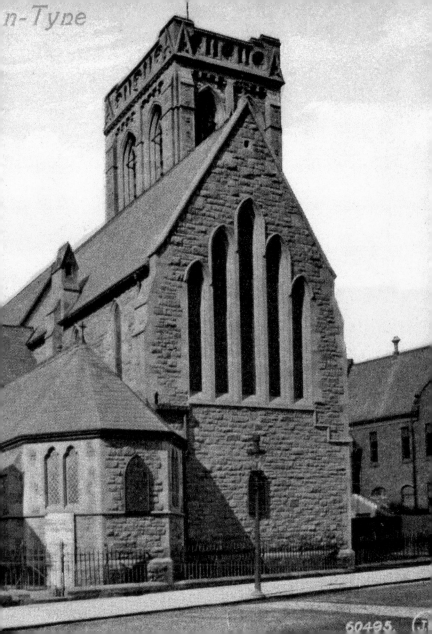

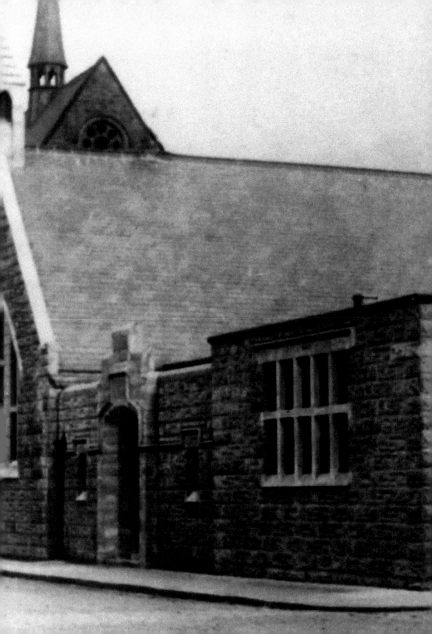

26. ST LUKE'S CHURCH HALL

In 1908 St Luke's church hall was built at the rear of St Luke's church on Frank Street. It served the church congregation and other local groups for 100 years, including, for a short time, Wallsend Local History Society. The concrete structure was showing its age when the decision was taken to demolish it. A block of flats and a new church hall, utilising part of the existing church, was approved to be built on the site. Wallsend Local History Society have now moved back into the new church hall for their monthly meetings, held at 7 p.m. every second Monday of the month.

27. OUR LADY AND ST COLUMBA ROMAN CATHOLIC CHURCH

A new church was erected in 1904 in Carville Road. It was built close to the Roman Catholic school built in 1876. The church dedicated to Our Lady and St Columba was constructed in temporary materials and was locally known as the 'Tin Church' or 'Cathedral'. It is seen here in 1920; the present church of the same name was built in 1957. St Columba's junior school was partly demolished and converted into a church hall with a car park following the building of a new school in Station Road.

28. OLD POLICE STATION

The original Wallsend Police Station is seen in the inset on the corner of The Avenue, High Street West and Portugal Place. It was built in the late 1800s with three cells and an exercise yard as well as police houses. The rear yard was shared with the officers of the first Wallsend fire brigade and access was gained through an archway from The Avenue. The inset photograph was taken in 1986 before a residential home was built on the site in 1990.

29. THE DUKE OF YORK

This view of the Duke of York public house on High Street West was taken in 1986. This was before the new housing was erected between the pub and West Street, on what used to be a car park and, before that, air raid shelters and a builder's yard. The Duke of York was built around 1900. Sting once atended the regular Folk Club held at the Duke of York when he lived in Wallsend.

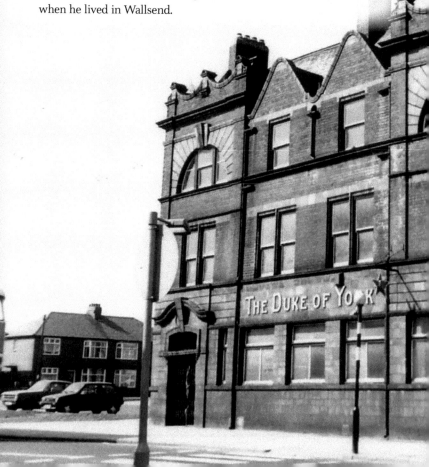

30. HIGH STREET WEST AND THE BLACK BULL HOTEL

The Black Bull Hotel features prominently in this picture of High Street West taken in the 1920s. The view looks west towards the boundary with Newcastle just out of the picture. The buildings to the west of the Black Bull were demolished in the late 1930s to make way for the Ritz Cinema that later became the Mecca Bingo Hall, and the Black Bull has also changed its name a few times in recent years.

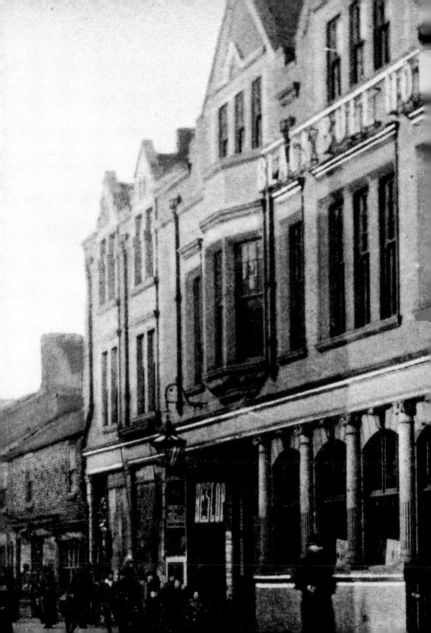

31. HIGH STREET EAST, LOOKING EAST FROM STATION ROAD

Boots the Chemist is seen on the corner of Station Road in the 1930s (*inset*), a site it occupied for decades before moving into the Forum in the 1960s. Another long established company was Hills Ironmongery, situated a few shops to the east of Boots. Further in the distance is the spire of the Brunswick Methodist church on the corner of Laburnum Avenue.

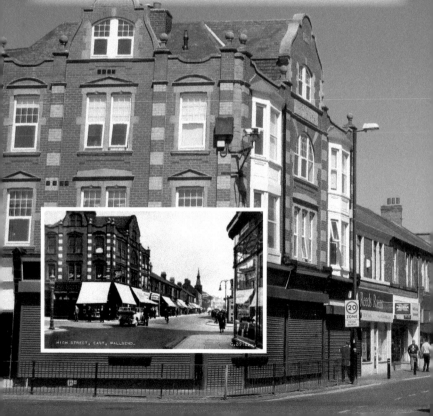

HIGH STREET, EAST, WALLSEND.

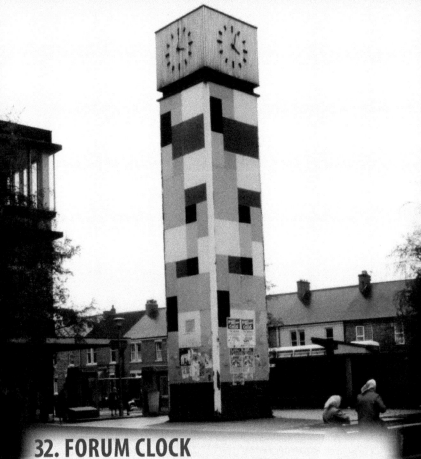

32. FORUM CLOCK

When Wallsend Forum Square was built in the mid-1960s the centrepiece of the development was the typical 1960s-style iconic square tower clock with its brightly coloured mosaic-style pattern. This view is from the early 1980s. The clock was removed when the Forum was redeveloped in the mid-1990s. The plinth is used as the main stage during the annual Wallsend Festival in July.

33. HIGH STREET WEST, LOOKING WEST FROM STATION ROAD

This is what High Street West looked like in the late 1930s, before the Forum Shopping Centre was built in the mid-1960s. The bank on the corner was built for the North Eastern Banking Co. and later became Martin's Bank. The Station Hotel beyond was known locally as the 'Penny Wet' as it served coffee and rum to shipyard workers for 1*d*.

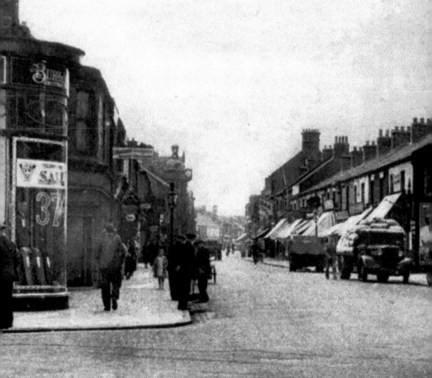

HIGH STRE

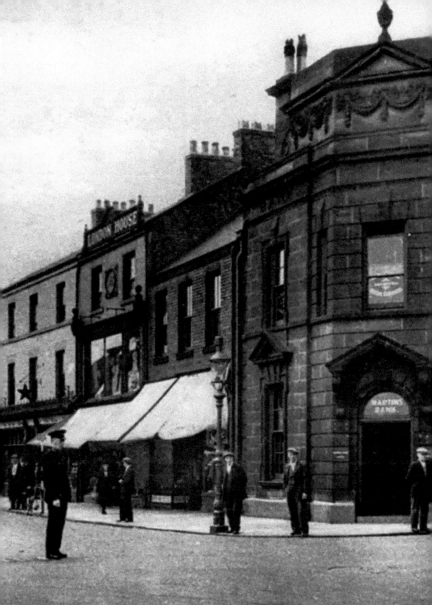

34. HIGH STREET

This view, taken around 1912 from High Street East, is looking at a tram in High Street West that is about to cross Station Road. The old buildings on the south-east corner of Station Road were cleared by 1916, and this site was later occupied by Woolworths. Boots occupied the opposite corner for many years before moving into the Forum Shopping Centre, which was developed in the mid-1960s.

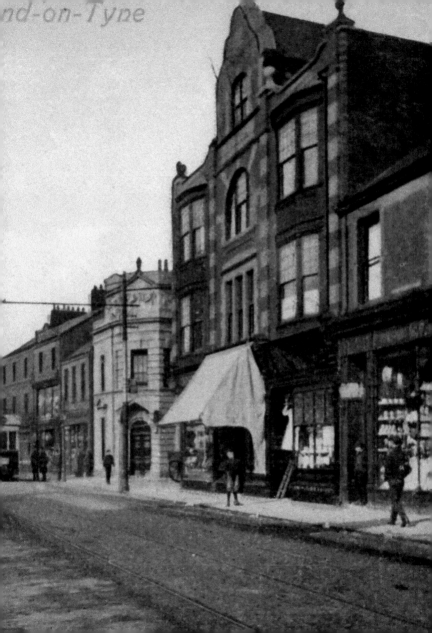

35. PARK ROAD, LOOKING NORTH

In 1910 this is what Park Road looked like, with the recently opened Borough Theatre dominating the street scene on the east side and a bank on the west side. The Borough Theatre was demolished in 2011 and has been redeveloped to provide housing. A bank operated from the other corner until the 1980s before changing into retail use.

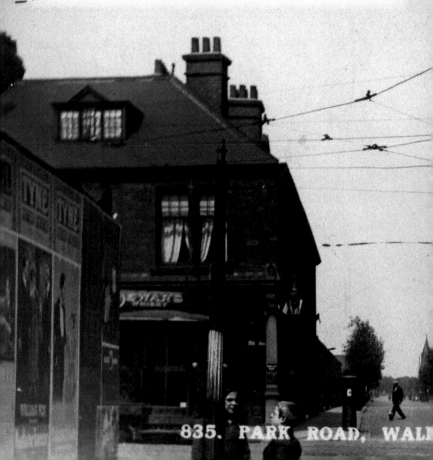

835. PARK ROAD, WAL

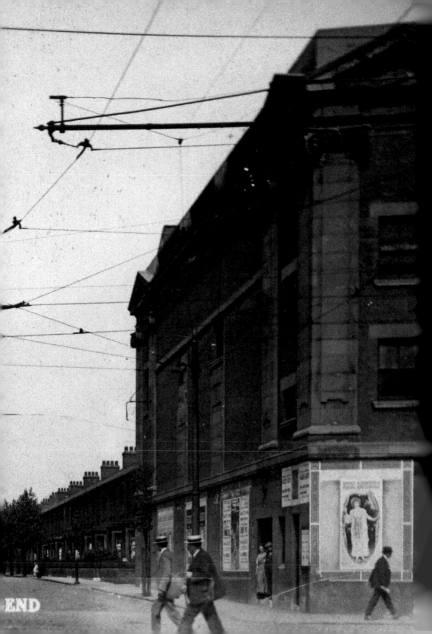

END

36. WALLSEND MUNICIPAL BUILDINGS FOUNDATION STONE

On 19 June 1907 the foundation stone for the Wallsend Municipal Buildings was laid by Alderman William Boyd, who had been the first mayor of Wallsend in 1901. The picture is taken looking north with Charlotte Street in the background. Every dignitary in the town was invited and have dressed for the occasion.

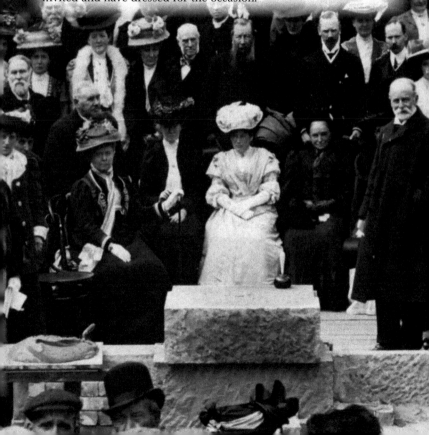

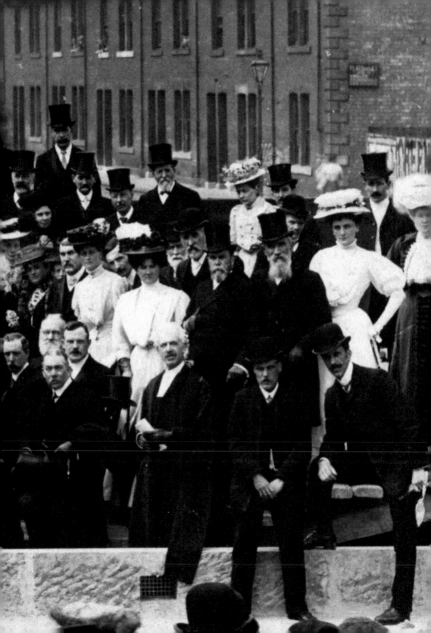

37. WALLSEND TOWN HALL

Wallsend Town Hall was built in 1908. It has changed little externally and is a listed building. After over a century of being used for civic purposes by successive councils, the building has recently been sold and it reopened in 2015 as a modern office and conference centre to be used by up to fifty small businesses. The Queen visited the town hall in 1954 and stood on the balcony to wave to the crowds during her coronation tour. The room behind has been renamed the Queen's Chamber to commemorate this visit. The building celebrated its centenary in 2008.

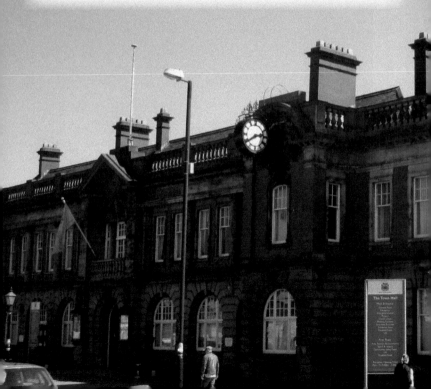

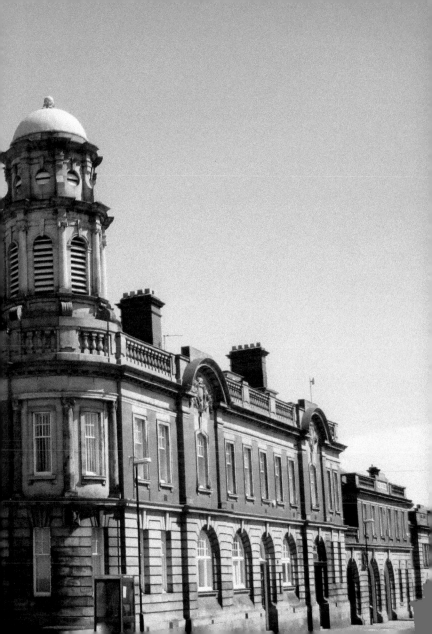

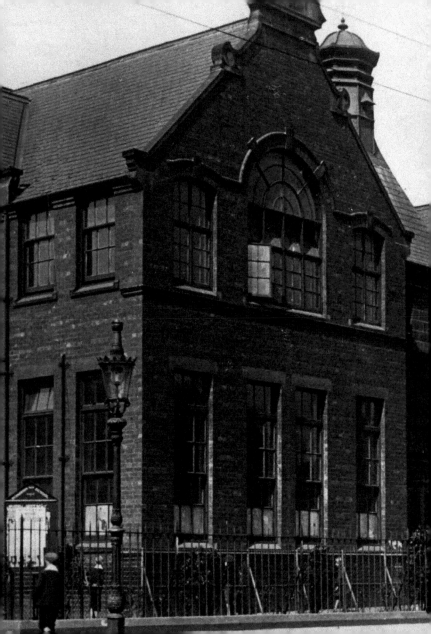

38. RICHARDSON DEES SCHOOL

Robert Richardson Dees was a solicitor who lived in Wallsend Hall from 1856 to 1908, when he died aged ninety-five. He donated the land at the former colliery C-Pit site to the council in 1897 to form a public park, which was named after him. When this school was built in 1902 it was also named after him. This postcard view was postmarked 1912.

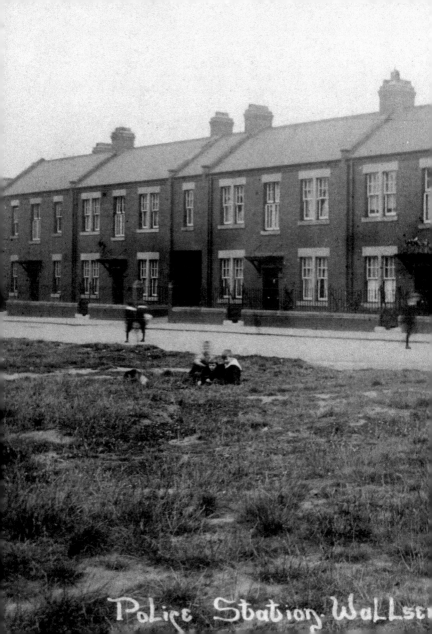

Police Station, Wallse

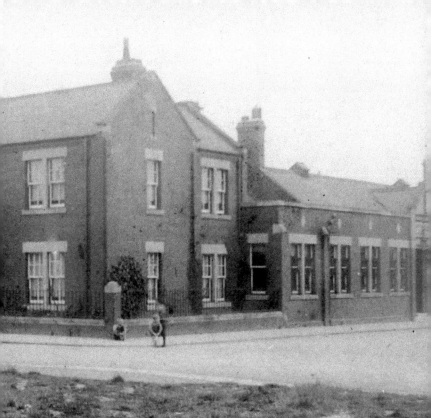

39. POLICE STATION

The police station was built in Alexandra Street in 1915 to replace the old police station on the corner of the Avenue and High Street West. This photograph must have been taken shortly after this, from the style of the clothes worn by the children. It also shows open land in the foreground, later to be converted to allotments that are still there today.

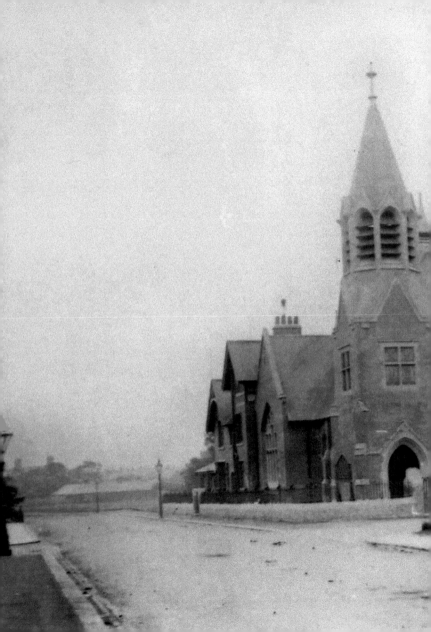

40. ALLEN MEMORIAL CHURCH FROM NORTH ROAD

The Allen Memorial church was built in 1904 and is seen here not long after its completion, and before the houses on North Road were built immediately in front. The buildings to the right of the church in the distance are the White House and adjoining farm buildings on the south side of Wallsend Green.

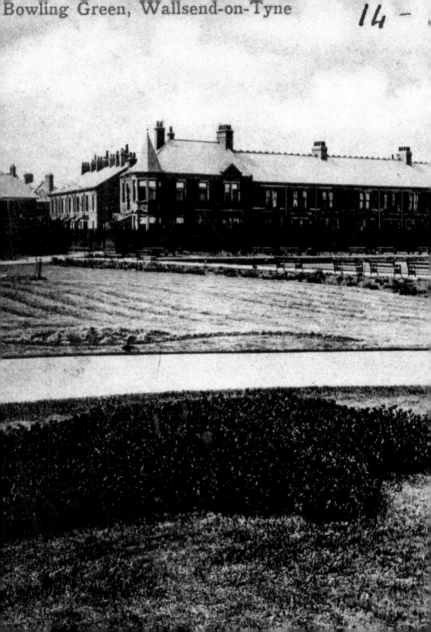

Bowling Green, Wallsend-on-Tyne

14 -

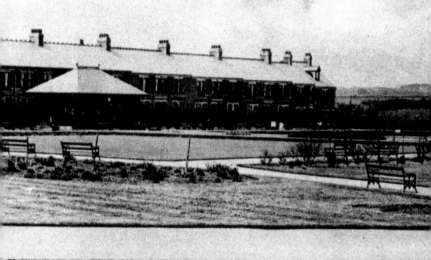

41. WALLSEND PARK BOWLING GREEN

The bowling green in Wallsend Park is seen around 1910 looking north-west towards Park View with views across rolling fields and a few isolated buildings. Today, the trees have grown to mask any view to the north, but the bowling greens are still popular with residents of Wallsend.

42. LAKE AND BRIDGE IN RICHARDSON DEES PARK

The owner of Wallsend Hall, Robert Richardson Dees, donated the site of the former Wallsend Colliery C-Pit to Wallsend Borough Council to be laid out as a public park and it opened in 1900. Workmen are seen putting the finishing touches to the landscaping around the park's lake in the early part of the 1900s. The landscaping has proved very successful and it is now impossible to capture the same view through the trees in the summer.

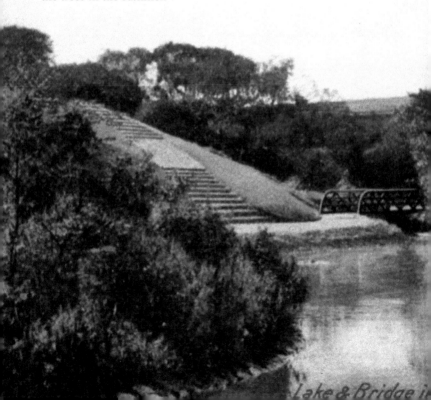

Lake & Bridge i

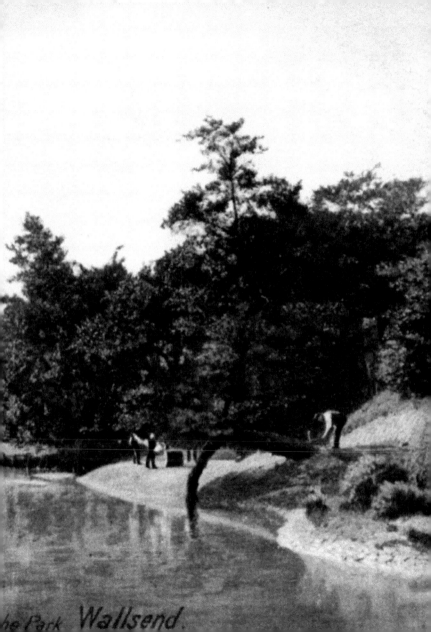

he Park Wallsend.

43. THE LAKE, WALLSEND PARK

The lake in Wallsend Park was formed as part of the overall works to create a public park on the site of wasteland previously forming part of the redundant colliery. The lake was formed where two water courses met. The wooded, steep-sided valleys still provide a wildlife haven, and the island built in the lake still provides a shelter for ducks and other wildlife. This image, on a postcard postmarked 1928, shows swans and ducks entertaining the children.

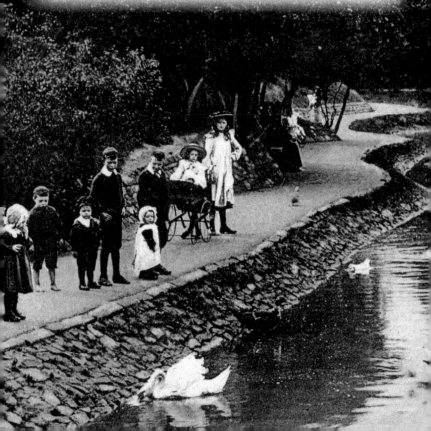

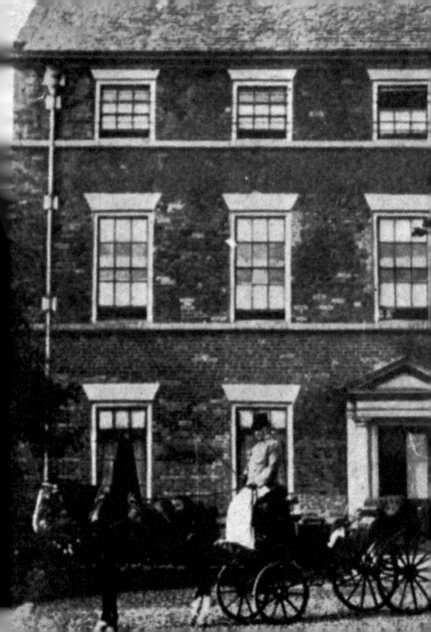

44. THE RED HOUSE, WALLSEND GREEN

The Red House was one of the original seven mansion houses occupied by the main landowners in Wallsend. Five were situated around the Green, namely The Hall, The Red House, The Grange, The White House and the Village Farm (St Nicholas Charity). The other two were Carville Hall and Point Pleasant Hall. The Red House was owned by John Allen, a chemical manufacturer in the late 1850s, who had the Allen Memorial church named after him. It was used as a disabled children's home from 1889 to 1897 before it was demolished and Park Villas and Hawthorn Villas were built on the site.

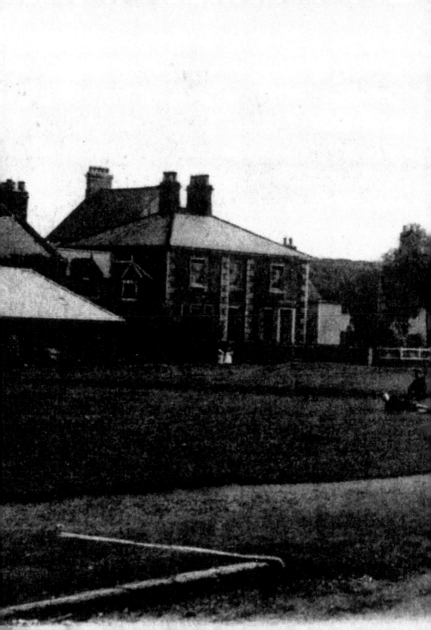

45. WALLSEND GREEN, LOOKING SOUTH-WEST AT THE WHITE HOUSE

The White House, concealed behind the trees, had a number of wealthy owners in the past, such as William Cramlington, one time mayor of Newcastle, who owned the property in 1787. The prominent building in the centre is the Villa, still standing to this day, which was built in the grounds of the White House in the 1850s and was occupied for some time by the Duffy family, who have a fountain to commemorate Joseph Duffy, a former mayor of Wallsend, in Richardson Dees Park. In 1910, the White House was demolished and a massive roller-skating rink known as the Stadium was built between the Green and North View. This eyesore had a variety of uses until it was demolished in 1986 and replaced by housing.

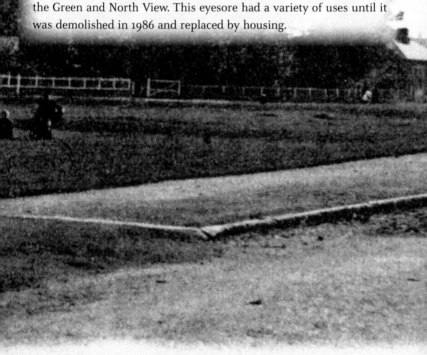

46. WALLSEND GREEN, LOOKING EAST

Wallsend Green dates back to medieval times and was the centre of a rural village until the coal and shipbuilding industries developed in Wallsend in the nineteenth century. The large building in the distance is Dene House, which was built on the garden of the Old School House, immediately to the left of it, on the corner of Crow Bank. This was the original village school and the schoolmasters, who were two generations of Joseph Mordue's, lived in the adjoining house from 1776 onwards. The village school doubled up as the parish church between 1797 and 1809 when Holy Cross church was closed. The world-famous railway and bridge engineer Robert Stephenson, son of George, was baptised here in 1804.

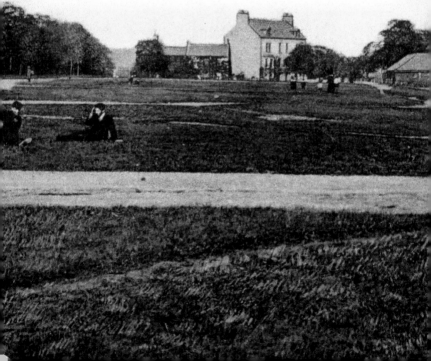

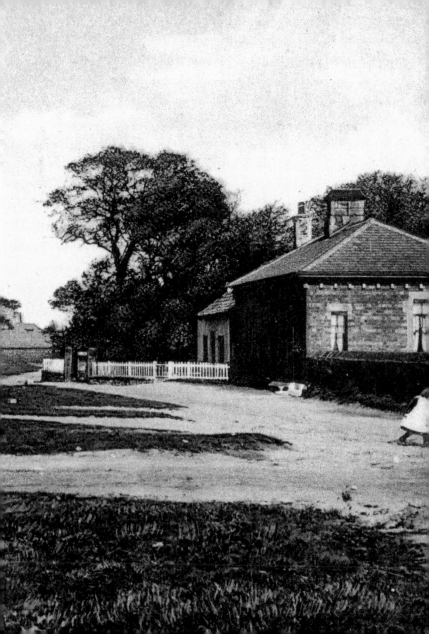